Cooperative Art

Written by **Jean Warren**

Illustrated by **Cora L. Walker**

 Totline® Publications
A Division of Frank Schaffer Publications, Inc.
Torrance, California

Totline Publications would like to thank the following people for their contributions to this book: Karel Kilimnik, Philadelphia, PA; Susan M. Paprocki, Northbrook, IL.

Managing Editor: Mina McMullin
Editor: Gayle Bittinger
Contributing Editors: Elizabeth S. McKinnon, Kathy Zaun
Assistant Editor: Claudia G. Reid
Editorial Assistant: Mary Newmaster
Graphic Designer (Interior): Jill Kaufman
Graphic Designer (Cover): Brenda Mann Harrison
Illustrator (Cover): Barb Tourtillotte
Production Manager: Janie Schmidt

Previously published as 1-2-3 Murals.

ISBN: 1-57029-279-5

Printed in the United States of America
Published by Totline® Publications
23740 Hawthorne Blvd.
Torrance, CA 90505

Introduction

Cooperative Art is filled with ideas for making eye-catching seasonal bulletin boards using child-created materials. Cooperation comes naturally as your children work together to create these delightful displays in which each child's artwork is valued as a part of the whole.

Every mural featured includes directions for an open-ended art activity and instructions for putting it all together to complete a scene. Several of the murals have patterns to accompany them. We encourage you to adapt the patterns and the murals to meet your individual needs and to use materials you have on hand.

You will find that fostering your children's creativity and encouraging cooperation is fun and easy with the ideas in *Cooperative Art*.

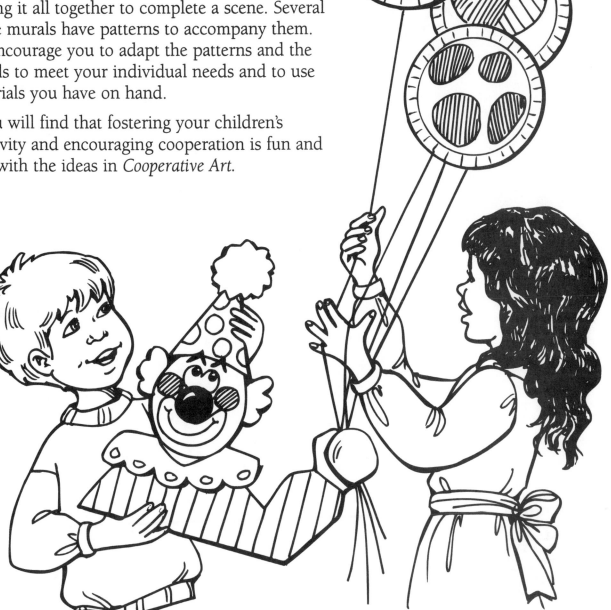

Contents

Murals

Happy Faces Mural

Materials Needed:

hand mirror
paper plates
butcher paper
construction paper
felt tip markers
yarn
glue
scissors

Cut small circles out of construction paper for eyes and cut yarn into hair-length pieces. Hang butcher paper on a wall or a bulletin board.

Give each child a paper plate. Have the children take turns looking at themselves in a hand mirror. Ask them to notice the colors of their hair and eyes. Then let them make self-portraits by gluing yarn "hair" and construction paper "eyes" that match their own hair and eye colors on their paper plates. Have the children complete their self-portraits by adding noses and mouths with felt tip markers.

Attach the self-portraits to the butcher paper and write the children's names below them. Add the words "Welcome, Happy Faces!" to the mural.

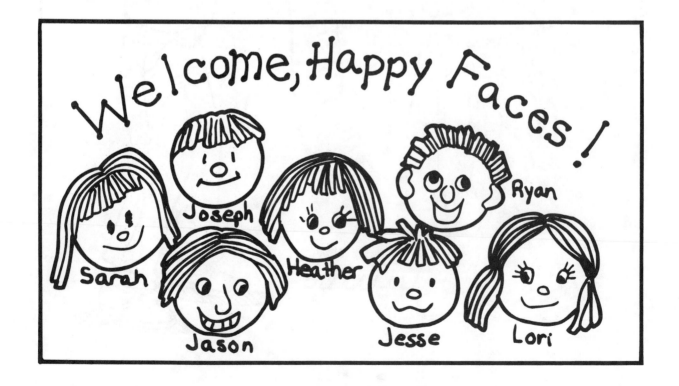

Clown Mural

Use felt tip markers to draw a clown figure on butcher paper. Hang the butcher paper on a wall or a bulletin board.

Give the children paper plates. Let them use tempera paints and paintbrushes to turn their paper plates into colorful balloons.

Attach a piece of yarn to each balloon plate, then attach the plates to the butcher paper. Gather all the yarn pieces together and fasten them to the clown's hand.

Materials Needed:

paper plates
butcher paper
tempera paints
paintbrushes
felt tip markers
yarn
scissors

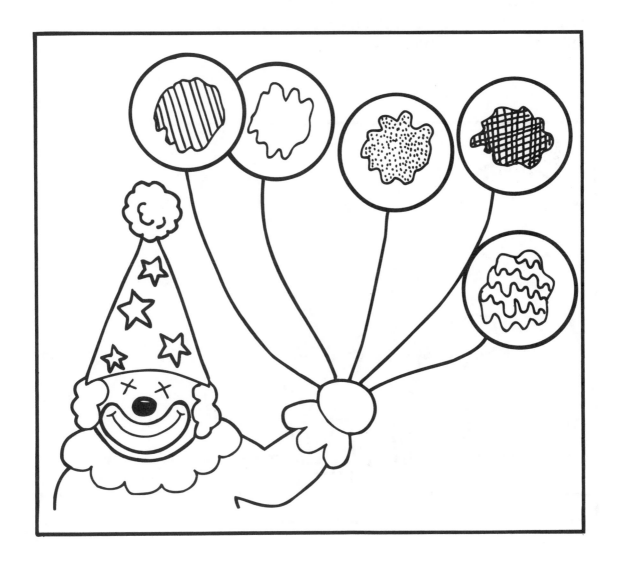

Dinosaur Swampland Mural

Hang blue butcher paper on a wall or a bulletin board. Cut three to four large dinosaur shapes out of dark green or brown butcher paper or posterboard. Then cut a 9-by-12-inch sheet of green construction paper in half lengthwise for each child.

Give each child one of the green construction paper rectangles. Have the children use scissors to cut slits along one of the long sides of their rectangles to make grass strips. Then give them each a second rectangle. Help them round off the ends of these rectangles before letting them cut all around their rectangles to make fern shapes.

Attach the fern and grass shapes to the butcher paper. Position the dinosaurs on the mural to look like they are grazing, walking, or standing in the swamp.

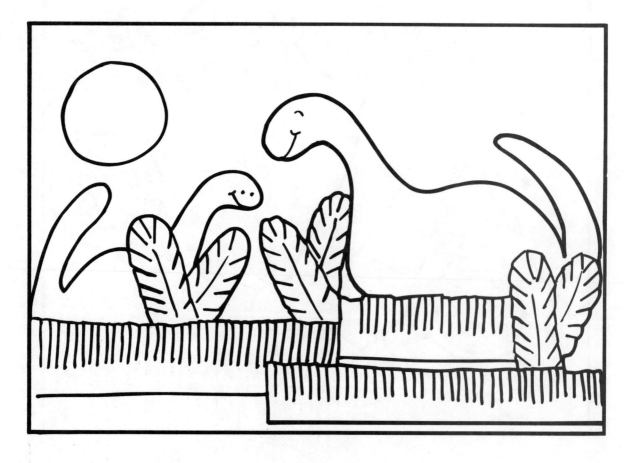

Autumn Leaves Mural

Paint a large brown tree with bare branches on butcher paper. Hang the paper on a wall or a bulletin board.

Let the children paint sheets of white typing paper with watercolor paints. Encourage them to use autumn leaf colors such as red, yellow, orange, and brown. When the paint has dried, use the patterns on pages 60 and 61 as guides to cut leaf shapes out of the papers.

Attach the leaf shapes to the butcher paper, some on the tree branches and some beneath the tree. If desired, cut squirrel and nut shapes out of construction paper and add them to the mural.

Materials Needed:

white typing paper

watercolor paints

butcher paper

brown tempera paint

paintbrushes

scissors

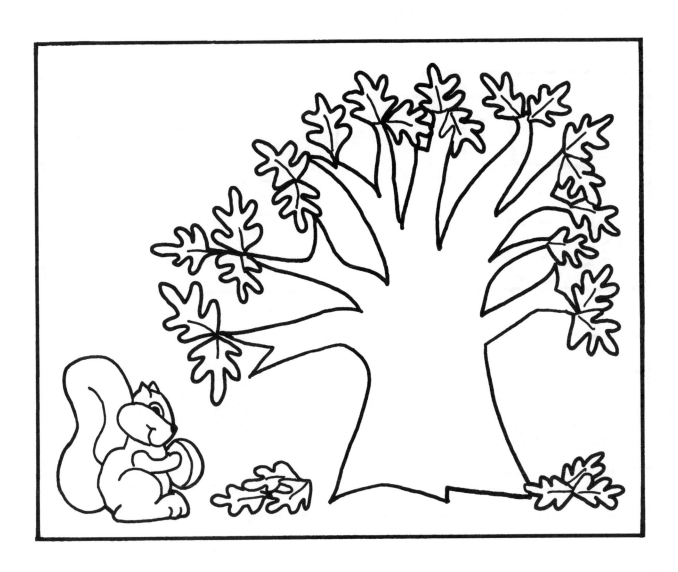

School Bus Mural

Use the patterns on pages 62 and 64 as guides to cut the front and back of a school bus shape out of white construction paper. Use the pattern on page 63 as a guide to cut out one middle section of the bus shape for every two children. Tape the sections together and place them on a table.

Let the children work together to paint the school bus shape yellow. Allow the paint to dry.

Outline the wheels and windows and draw other details on the bus shape with a black felt tip marker. Cut out the windows and glue a photo of one child in each window opening. Hang the school bus mural on a wall at the children's eye level.

Materials Needed:

photo of each child
white construction paper
yellow tempera paint
paintbrushes
black felt tip marker
tape
glue
scissors

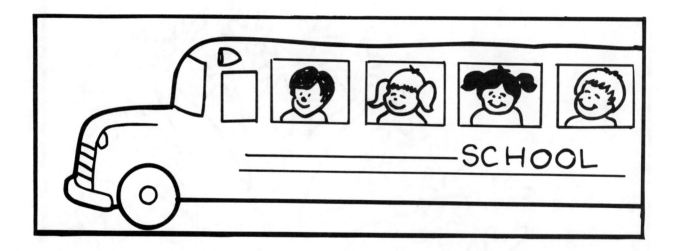

Columbus Day Mural

Use the pattern on page 65 as a guide to cut three ship shapes out of brown construction paper. Make sails for the ships by cutting white cloth into sail shapes. Hang blue butcher paper on a wall or a bulletin board and attach the ship and sail shapes to the paper. Cut 2-by-8-inch strips out of blue construction paper. Set out the paper strips and glue.

Show the children how to fasten the ends of the strips together with glue to make paper chains. Then let them make their own chains with as many loops as they wish.

Attach the paper chains in wavy lines underneath the ships on the butcher paper to make an ocean.

Materials Needed:

white cloth
blue butcher paper
blue and brown
construction paper
glue
scissors
ruler

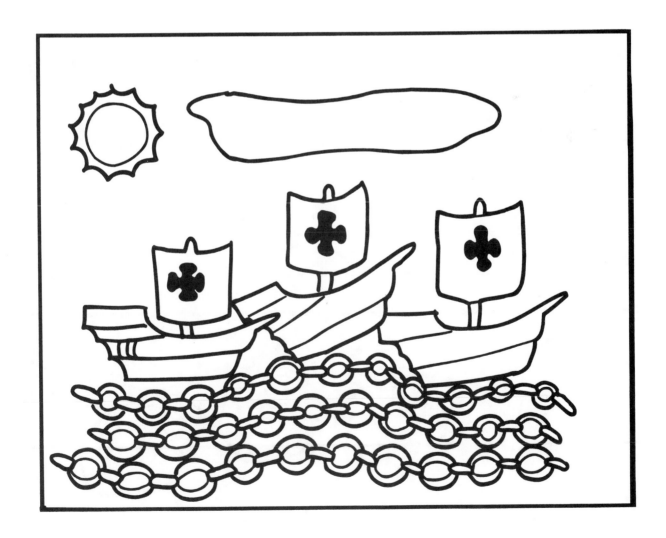

Pumpkin Patch Mural

Use the patterns on page 66 as a guide to cut pumpkin leaf shapes out of green construction paper. Attach a long piece of brown butcher paper to a wall at the children's eye level.

Give each child a small paper bag. Have the children stuff their bags with crumpled pieces of newspaper. Secure each bag with a green twist tie, leaving about 1 inch gathered at the top. Then let the children paint the bottom parts of their bags orange and the top parts green to create pumpkins with stems.

String the pumpkins together with a long piece of green yarn and attach them to the butcher paper. Tape the green leaves on the pumpkin stems and the green yarn "vine."

Materials Needed:

small paper bags
newspapers
green twist ties
brown butcher paper
green construction paper
orange and green
tempera paint
paintbrushes
green yarn
tape
scissors

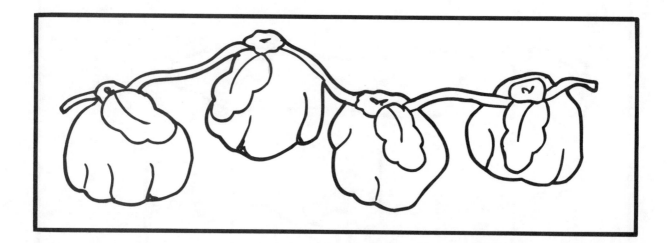

Turkeys in the Barnyard Mural

Materials Needed:

butcher paper

brown and red tempera paints

paintbrushes

black felt tip markers

construction paper

scissors

glue

Cut a large barn shape, a fence shape, and other barnyard shapes out of construction paper. Glue the shapes on butcher paper to create a barnyard scene. Place the butcher paper on a table.

Let the children make turkey handprints all over the barnyard scene. Have them paint their fingers and palms brown and their thumbs red. Then have them press their hands, painted sides down, on the butcher paper, leaving "turkey" prints. After the paint dries, let the children add eyes, beaks, legs, and feet to their turkey prints with black felt tip markers.

Hang the barnyard mural on a wall or a bulletin board.

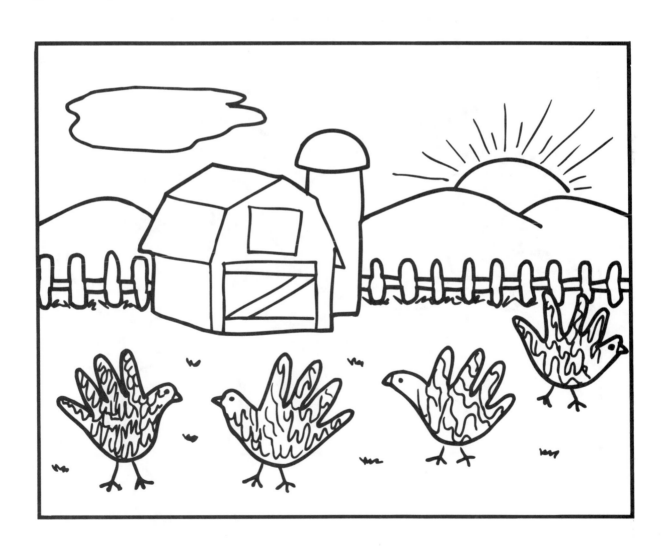

Turkey Feathers Mural

Cut a large turkey shape out of brown butcher paper and hang it on a wall or a bulletin board. Cut large turkey feather shapes out of construction paper. Pour several colors of tempera paint into shallow containers.

Give the children the feather shapes and feathers. Let them use their feathers as brushes to paint designs on their feather shapes.

Attach the painted feather shapes to the turkey shape.

Materials Needed:

feathers
brown butcher paper
construction paper
tempera paints
shallow containers
scissors

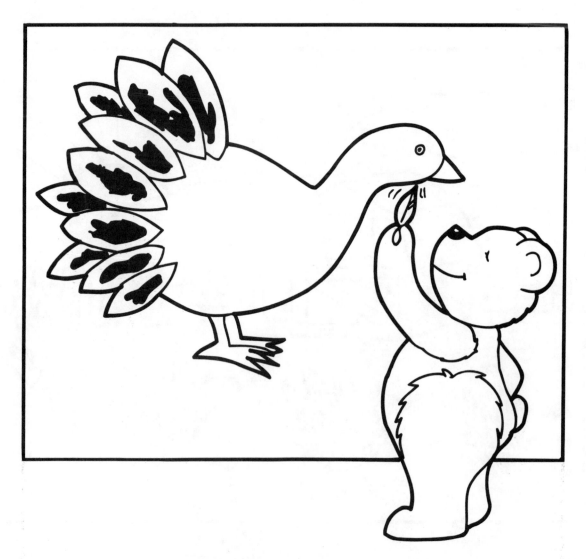

Thanksgiving Quilt Mural

Cut 9-inch squares out of construction paper. Crease the squares diagonally both ways. Cut diamond shapes out of colorful paper and aluminum foil.

Give each child one of the creased construction paper squares. Let the children glue the diamond shapes on their squares in patterns. Show them how to use the creases on their squares as guidelines.

Arrange the squares in a rectangular shape on the floor and tape them all together. Carefully hang the paper quilt on a wall or a bulletin board.

Materials Needed:

aluminum foil
scraps of colorful paper
construction paper
tape
glue
scissors
ruler

Thanksgiving Dinner Mural

Cut a cornucopia shape and several different fruit shapes out of construction paper. Glue them to the center of a paper tablecloth.

Let the children look through magazines to find pictures of foods. Have them tear out the pictures and glue them on paper plates.

Attach the paper plates around the edges of the tablecloth. If desired, let the children glue plastic forks, knives, and spoons next to the plates. Then hang the tablecloth on a wall or a bulletin board.

Materials
Needed:

large paper tablecloth

paper plates

magazines

construction paper

glue

scissors

plastic forks, knives, and
spoons (optional)

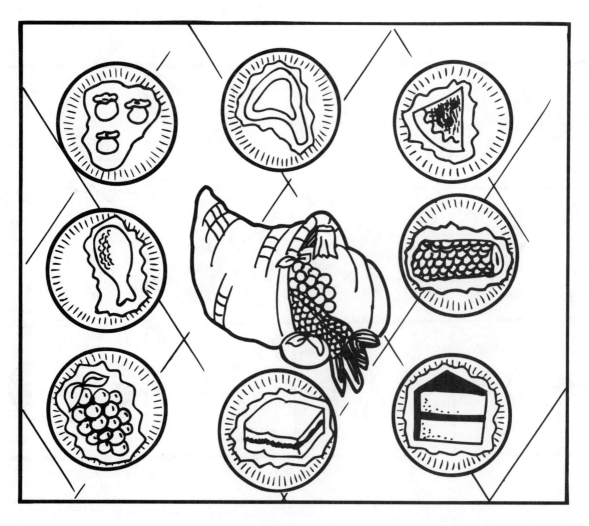

Log Cabin Mural

Cut the bottom flaps off of brown paper bags. Roll each bag lengthwise around a dowel. Secure with tape to keep the bag from unrolling, then take the dowel out. Continue this procedure to make as many "logs" as desired. Place butcher paper on a table or on the floor.

Give the children the paper bag logs. Let them work together to glue the logs in a log cabin shape on the butcher paper.

Hang the mural on a wall or a bulletin board. Add tree shapes and a chimney shape cut out of construction paper, if desired.

Materials Needed:

dowel
brown paper bags
butcher paper
tape
glue
scissors
construction paper
(optional)

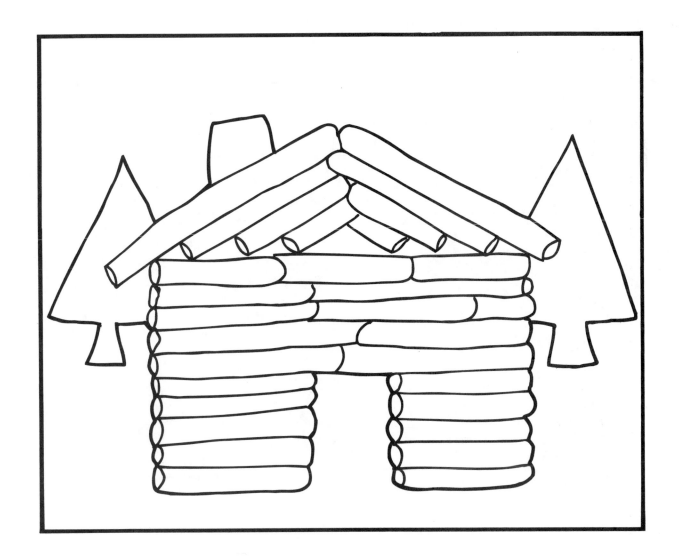

Hanukkah Mural

Materials Needed:

gold glitter

yellow construction paper

blue butcher paper

cotton swabs

craft sticks

glue

shallow containers

scissors

Hang blue butcher paper on a wall or a bulletin board. Cut out yellow construction paper letters to spell "Happy Hanukkah" and attach them to the top of the butcher paper. Pour small amounts of glue into shallow containers.

Give each child six craft sticks. Have the children use cotton swabs to cover their craft sticks with glue. Then let them sprinkle gold glitter over the glue. Have them wait a few moments before shaking off the excess glitter. Show each child how to glue his or her craft sticks together to make two triangles. Allow the glue to dry. Then help each child glue his or her triangles together to make a Star of David.

Attach each child's Star of David to the butcher paper.

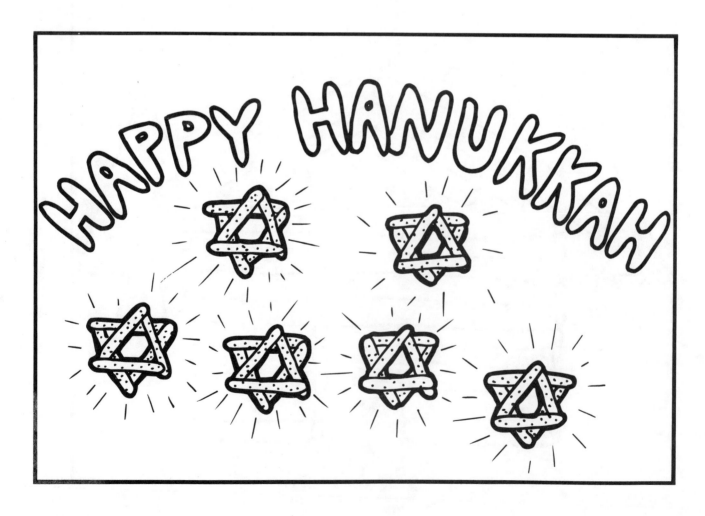

Popcorn Wreath Mural

Cut a large wreath shape out of posterboard. Hang butcher paper on a wall or a bulletin board. Use a piece of ribbon to make a bow. Pour small amounts of glue into shallow containers.

Have the children dip pieces of popped popcorn into the glue and place them all over the wreath shape. Let them continue until the wreath is completely covered with popcorn.

Add the bow to the top of the popcorn wreath and attach the wreath to the butcher paper.

Materials Needed:

popped popcorn
ribbon
posterboard
butcher paper
glue
shallow containers
scissors

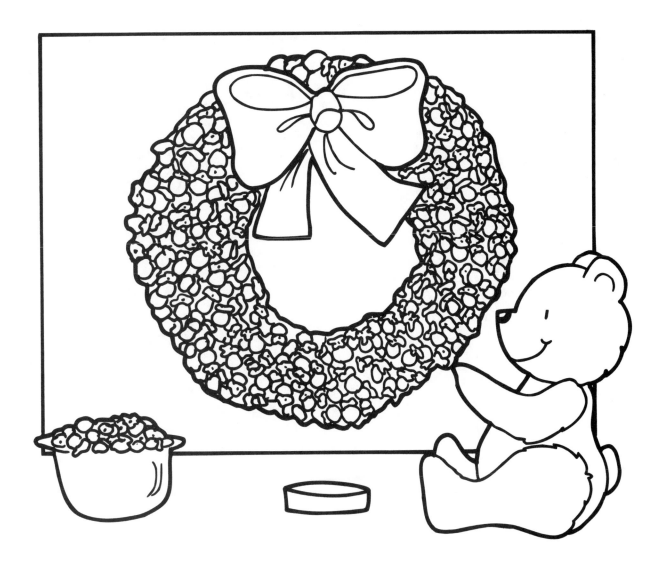

Christmas Wreath Mural

Hang butcher paper on a wall or a bulletin board. Cut a bow shape out of red construction paper.

Give the children pieces of green construction paper and pencils. Help the children use the pencils to trace around their hands on the construction paper. Let them cut out their hand shapes.

Overlap the hand shapes in a circle on the butcher paper to make a wreath. Glue the bow shape to the bottom of the wreath.

Materials Needed:

pencils

butcher paper

red and green construction paper

glue

scissors

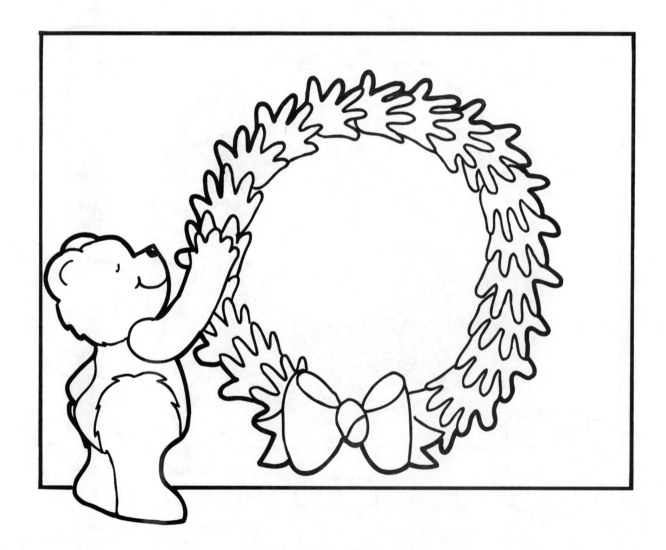

Tree of Hands Mural

Hang butcher paper on a wall or a bulletin board. Use felt tip markers to write the words "Happy Holidays" at the top. Cut a large star shape out of aluminum foil.

Give the children pieces of green construction paper and pencils. Help the children use the pencils to trace around their hands on the construction paper. Let them cut out their hand shapes.

Use the hand shapes to make a large Christmas tree shape on the butcher paper. Starting at the bottom, overlap the hands in progressively shorter rows with the fingers pointing down. Decorate the tree by attaching the large foil star at the top.

Materials Needed:

aluminum foil

pencils

butcher paper

green construction paper

felt tip markers

scissors

 Extension Activity

Make presents to put under your tree by having the children fold pieces of foil wrapping paper around small squares and rectangles cut out of cardboard. Let them decorate the presents with self-stick bows. Attach the presents to the mural.

Triangle Tree Mural

Cut 12-by-12-by-12-inch triangles out of green construction paper. (You will need a total of four, nine, or sixteen triangles to complete a tree.) Hang butcher paper on a wall or a bulletin board.

Give each child a triangle and six foil cupcake liners. Have the children flatten their liners and glue them, shiny sides up, on their triangles. Let the children decorate their triangles with stickers, fabric and felt scraps, beads, buttons, glitter, or sequins.

Attach the decorated triangles in a tree shape on the butcher paper. If you have four triangles, place three on the bottom (alternating point up, point down), then place the fourth triangle on the top, point up. If you have nine triangles, alternate five triangles on the bottom, three on the second row, and one on top. If you have sixteen triangles, alternate seven triangles on the bottom, five on the second row, three on the third row, and one on top. Use felt tip markers to add a star, a tree trunk, and several Christmas packages to the mural, if desired.

Materials Needed:

foil cupcake liners

assortment of stickers, fabric and felt scraps, beads, buttons, glitter, and sequins

butcher paper

green construction paper

glue

scissors

ruler

felt tip marker (optional)

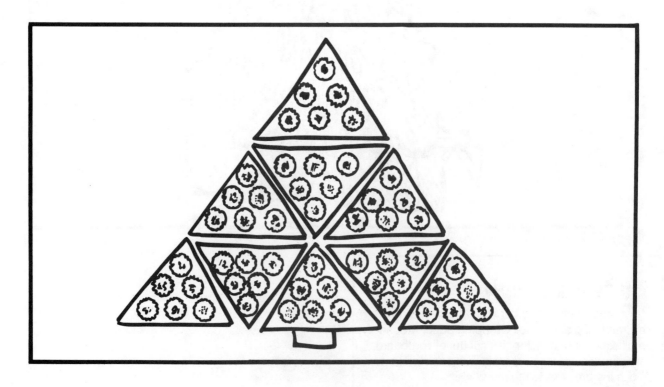

Toy Train Mural

Materials Needed:

magazines and
toy catalogs

butcher paper

construction paper

glue

scissors

Use the patterns on pages 67 and 69 as guides to cut an engine shape and a caboose shape out of construction paper. Then use the pattern on page 68 as a guide to cut out a construction paper boxcar shape for each child. Hang a long piece of butcher paper on a wall at the children's eye level.

Let the children look through magazines and toy catalogs and tear out pictures of their favorite toys. Give them each a boxcar shape and have them glue on their toy pictures.

Attach the engine shape, all of the boxcar shapes, and the caboose shape to the butcher paper to complete the mural.

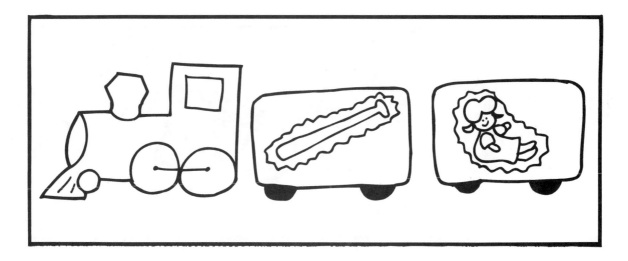

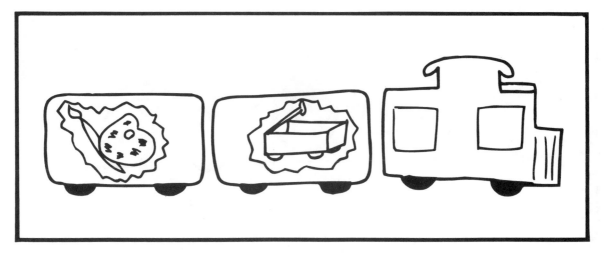

Ornament Mural

Use the patterns on pages 70 and 71 as guides to cut ornament shapes out of construction paper. Hang a long piece of butcher paper on a wall at the children's eye level. Use a green felt tip marker to draw evergreen branches across the top part of the butcher paper. Pour small amounts of glue into shallow containers.

Give the children the ornament shapes. Let them dip cotton swabs into the glue and use them to make designs on their shapes. Then have the children sprinkle glitter all over the glue. Have them wait a few seconds before shaking off the excess glitter.

Let the children help tape the ornaments to the evergreen branches on the butcher paper.

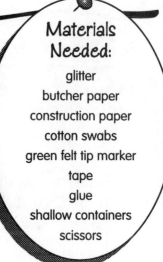

Materials Needed:

glitter
butcher paper
construction paper
cotton swabs
green felt tip marker
tape
glue
shallow containers
scissors

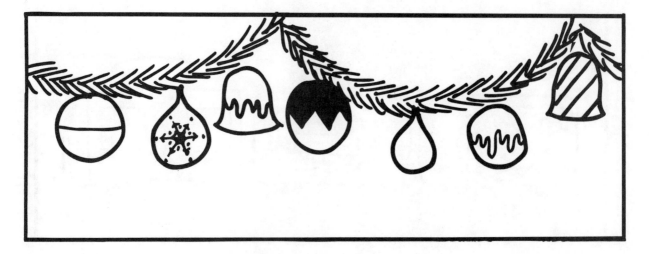

Snow Pal Mural

Cut two large circles out of white butcher paper, making one slightly smaller than the other. Place the circles on a table. Pour small amounts of glue into shallow containers. Set out the containers and cotton balls.

Let the children dip the cotton balls into the glue and place them all over the circles. Have them continue until the circles are completely covered with cotton balls.

Put the Snow Pal Mural together by attaching the circles to a wall or a bulletin board with the larger circle on the bottom. Then decorate the snow pal with facial features and clothing shapes cut out of construction paper.

Materials Needed:

cotton balls
white butcher paper
construction paper
glue
shallow containers
scissors

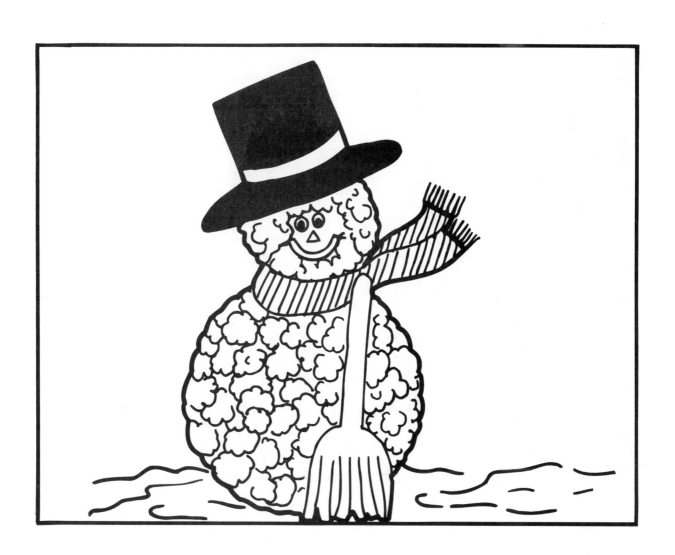

Snowscene Mural

Cut a house shape out of construction paper and glue it on blue or black butcher paper. Pour small amounts of glue into shallow containers. Place the butcher paper on a table.

Let the children dip cotton balls into the glue and place them all over the butcher paper for snowflakes. Show the children how to fluff out some of the cotton balls and glue them in front of the house shape to make a snowy lawn.

Hang the mural on a wall or a bulletin board.

Materials Needed:

cotton balls
blue or black butcher paper
construction paper
glue
shallow containers
scissors

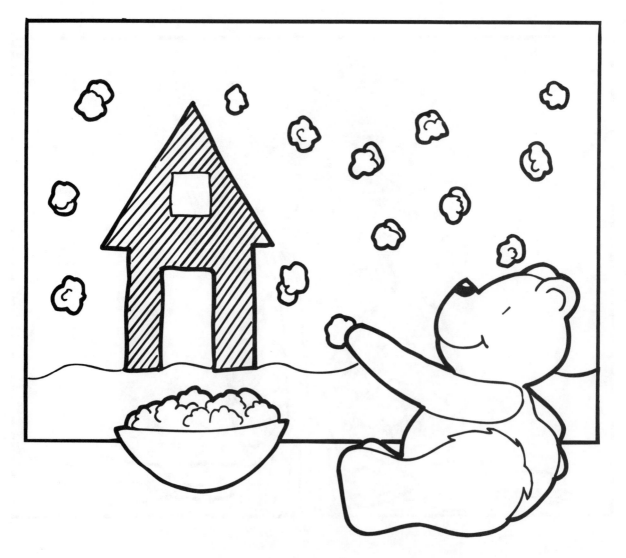

Winter Forest Mural

Hang light blue butcher paper on a wall or a bulletin board. Cut a pond shape out of aluminum foil and attach it to the center of the paper. Use the pattern on page 72 as a guide to cut tree shapes out of green construction paper. In small bowls, stir soap flakes with water until the mixture is thick and creamy.

Give each child a tree shape and a paintbrush. Let the children brush the soap flake mixture over their tree shapes to create a snowy look. Allow the shapes to dry.

Attach the snow-covered trees around the pond shape on the butcher paper to create a winter scene.

Materials Needed:

aluminum foil

soap flakes

water

small bowls

spoon

light blue butcher paper

green construction paper

paintbrushes

scissors

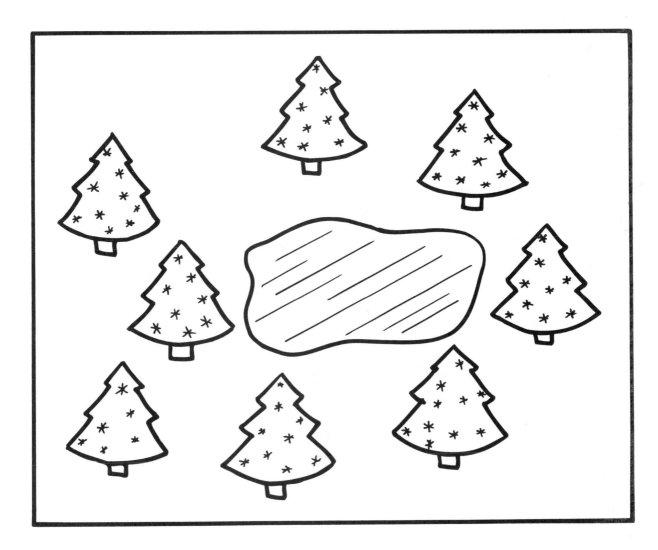

Dot-to-Dot Mural

Hang a long piece of butcher paper on a wall at the children's eye level.

Give each child several self-stick circles. Let the children place their circles all over the butcher paper.

Have the children use crayons to draw lines from "dot to dot" to complete the mural.

Materials Needed:

self-stick circles

crayons

butcher paper

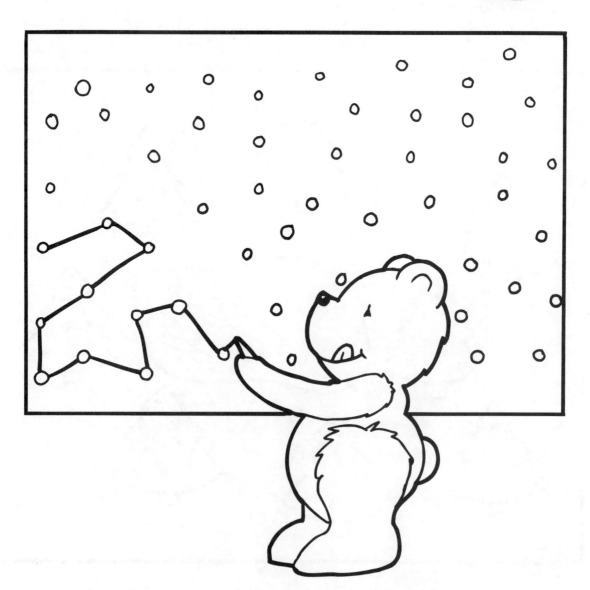

Valentine Heart Mural

Cut a large heart shape out of red posterboard and cut it into puzzle pieces (one for each child). Mark the back side of each puzzle piece with a felt tip marker.

Give each child a puzzle piece and sheets of red, pink, and white construction paper. Let the children tear their construction paper into small pieces. Have them place their puzzle pieces on a table with the marked sides facing down. Then let them glue their torn-up papers all over their puzzle pieces.

Help the children assemble and glue the heart puzzle on a piece of butcher paper. Hang the heart puzzle on a wall or a bulletin board.

Materials Needed:

red posterboard

butcher paper

red, pink, and white construction paper

felt tip marker

glue

scissors

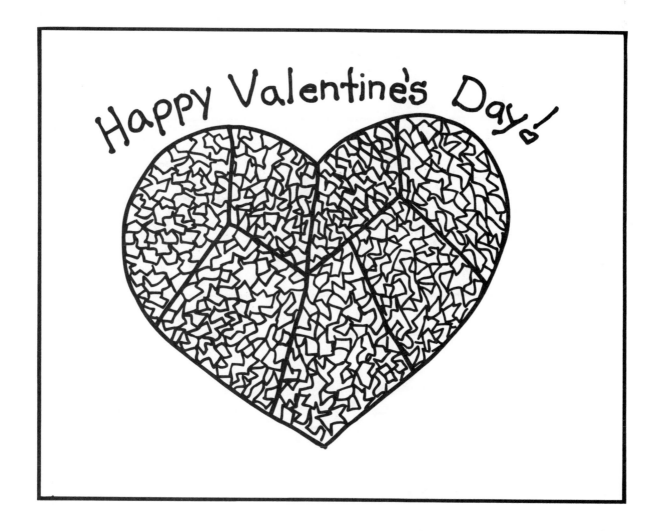

Queen of Hearts Mural

Materials Needed:

3" x 3" self-stick removable note pad

old deck of playing cards

butcher paper

construction paper

felt tip markers

glue

scissors

ruler

Separate the cards in the heart suit from the rest of the cards in a deck of playing cards. Cut sheets of a 3-by-3-inch self-stick removable note pad into four strips so that part of the sticky strip is on each piece. Then cut one small heart per child out of construction paper. Hang a long piece of butcher paper on a wall at the children's eye level. Cut six more hearts out of construction paper to make a simple "Queen of Hearts" as shown below. Attach the Queen of Hearts to the butcher paper.

Give each child four of the self-stick removable note pad strips, a heart playing card, and a small paper heart. Let the children arrange their strips on their cards like arms and legs. To complete their heart people, have them glue their paper hearts to the tops of their cards for heads and add faces with felt tip markers.

Attach the heart people to the butcher paper in rows, next to the Queen of Hearts.

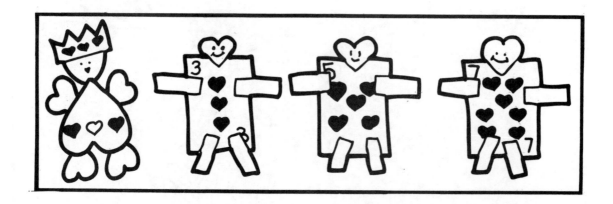

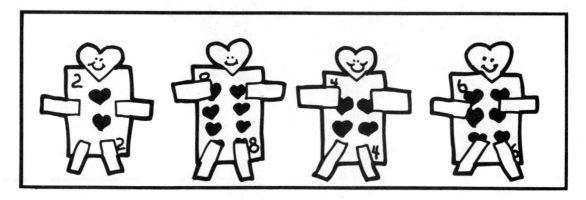

Brick Building Mural

Fold pieces of red construction paper in thirds. Hang butcher paper on a wall at the children's eye level.

Give each child a piece of the folded red construction paper. Have the children cut their papers along the folds to create construction paper "bricks."

Let the children work together gluing bricks to the butcher paper to build a structure such as a house, a fort, or a wall.

Materials Needed:
butcher paper
red construction paper
glue
scissors

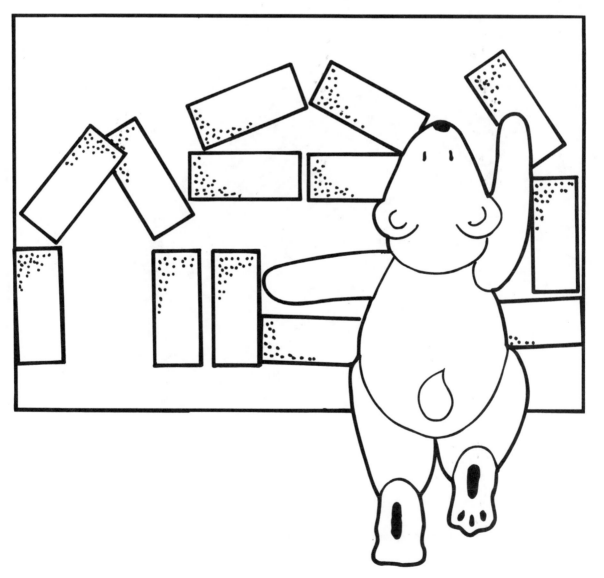

Pot of Gold Mural

Cut red, orange, yellow, green, blue, and purple construction paper into 2-by-8-inch strips. Hang butcher paper on a wall or a bulletin board. Cut a pot shape out of black posterboard and attach it to one side of the butcher paper.

Show the children how to tape the ends of the construction paper strips together to make paper chains. Then have the children work together to create six paper chains, one of each color.

Attach the paper chains to the butcher paper to make a rainbow shape that ends in the "pot of gold." Add a construction paper leprechaun shape and shamrock shapes to the mural, if desired.

Materials Needed:

black posterboard

butcher paper

red, orange, yellow, green, blue, and purple construction paper

tape

scissors

ruler

leprechaun and shamrock shapes (optional)

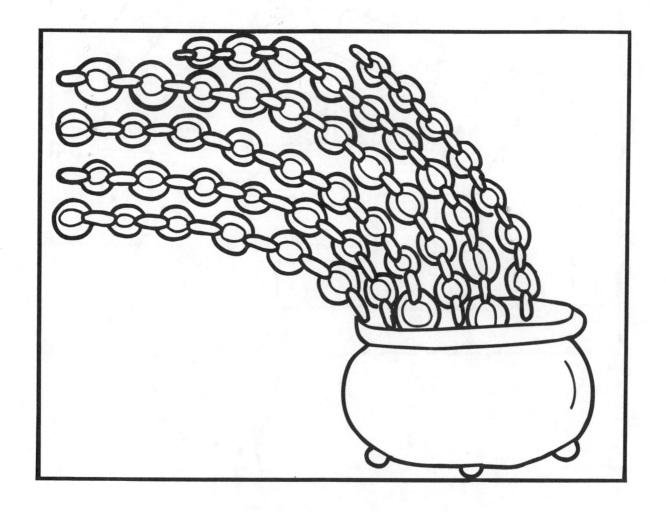

Shamrock Puzzle Mural

Cut a large shamrock shape out of posterboard. Cut the shape into puzzle pieces (one for each child). Mark the back side of each puzzle piece with a felt tip marker. Cut green construction paper or tissue paper into small squares. Pour small amounts of glue into shallow containers.

Let the children use cotton swabs to spread glue over the unmarked sides of their puzzle pieces. Then have them cover the glue with squares of green paper to create mosaic designs.

Help the children put the shamrock puzzle together and glue it on a piece of butcher paper. Then hang the shamrock mural on a wall or a bulletin board.

Materials Needed:

posterboard
butcher paper
various shades of green
construction paper or
tissue paper
cotton swabs
felt tip marker
glue
shallow containers
scissors

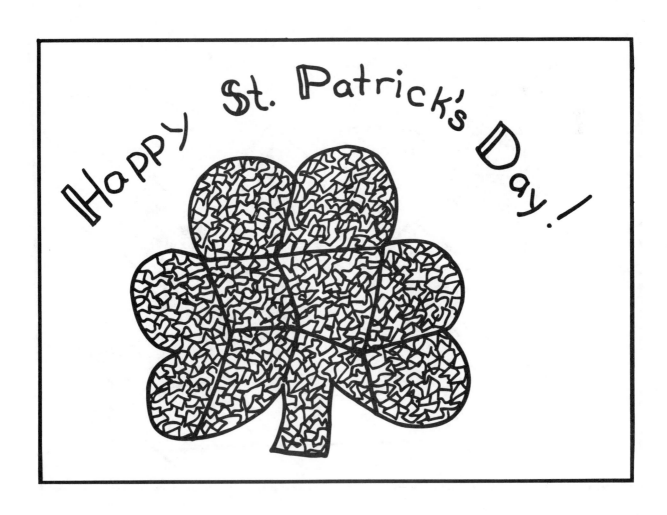

March Kites Mural

Cut kite shapes out of construction paper. Fold each shape in half lengthwise. Hang blue butcher paper on a wall or a bulletin board. Fluff out several cotton balls and glue them on the butcher paper for clouds.

Give each child a kite shape. Let the children unfold their shapes and use eyedroppers to squeeze drops of tempera paint on one side of their papers. Then have them refold their shapes and rub their hands gently across the tops. Let them open up their kite shapes to reveal the designs they have made. Attach pieces of yarn to the shapes for kite strings.

Attach the kite shapes to the butcher paper "sky." If desired, add construction paper bird shapes to the mural.

Materials Needed:

eyedroppers
cotton balls
blue butcher paper
construction paper
tempera paints
yarn
glue
scissors

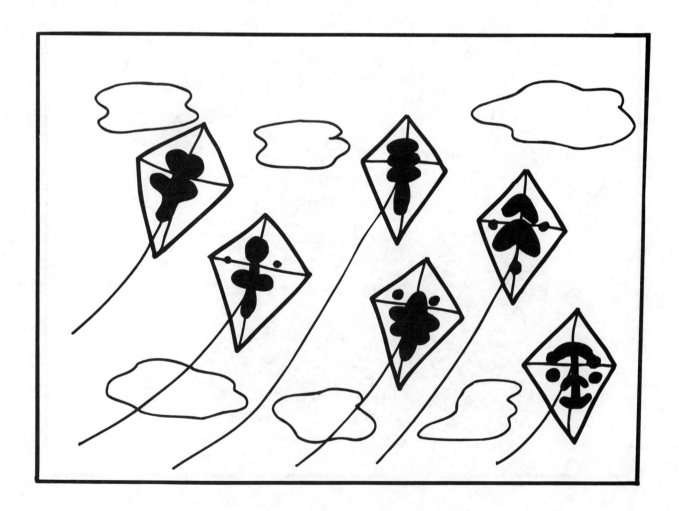

Night Sky Mural

Use the pattern on page 73 as a guide to cut star shapes out of posterboard. Tear aluminum foil into 16-inch sheets. Hang dark blue or black butcher paper on a wall or a bulletin board.

Set out the star shapes and the sheets of foil. Let the children carefully wrap the foil around the stars.

Attach the foil-covered stars to the butcher paper. Add a yellow construction paper moon shape to complete the night sky scene.

Materials Needed:

posterboard
aluminum foil
dark blue or black butcher paper
yellow construction paper
scissors
ruler

Easter Parade Mural

Use the patterns on pages 74 and 75 as guides to cut a bunny body shape and two bunny ear shapes for each child out of white construction paper. Then use the hat pattern on page 75 as a guide to cut brimmed hat shapes out of yellow construction paper. Hang a long piece of butcher paper on a wall at the children's eye level.

Give each child a bunny body shape, two bunny ear shapes, and a hat shape. Have the children glue their bunny ears and their hat shapes to their bunny bodies. Then let them decorate their hats by gluing on such materials as straw flowers, ribbon, rickrack, feathers, buttons, stickers, and sequins.

Attach the bunnies to the butcher paper to create an "Easter Parade."

Materials Needed:

decorating materials such as ribbon, rickrack, feathers, buttons, stickers, and sequins

butcher paper

white and yellow construction paper

glue

scissors

Easter Egg Mural

Mix evaporated milk with drops of food coloring in the cups of a muffin tin. Hang butcher paper on a wall or a bulletin board. Cut a large basket shape out of brown posterboard, burlap, or corduroy and attach it to the butcher paper.

Give each child a piece of white construction paper or typing paper. Have the children use paintbrushes to paint designs on their papers with the colored milk. Let the papers dry for six to eight hours before cutting them into egg shapes.

Attach the egg shapes in and around the basket shape on the butcher paper. Add some Easter grass to the top of the basket.

Materials Needed:

evaporated milk
food coloring
muffin tin
Easter grass
brown posterboard,
burlap, or corduroy
butcher paper
white construction paper
or typing paper
paintbrushes
scissors

Bunny Trail Mural

Use the pattern on page 76 as a guide to cut bunny shapes out of white construction paper. Cut sheets of green construction paper in half lengthwise. Cut egg shapes out of white construction paper. Attach a long piece of butcher paper to a wall at the children's eye level.

Give each child a bunny shape, a half sheet of green construction paper, and several egg shapes. Have the children cut slits along one of the long sides of their green construction paper pieces to make grass strips. Then have them glue cotton ball tails on their bunny shapes and decorate their egg shapes with felt tip markers.

Help the children glue their grass strips to the butcher paper to create a trail. Then let them glue their bunny shapes all along the grass trail and their egg shapes beside the trail.

Materials Needed:

cotton balls

butcher paper

white and green construction paper

butcher paper

felt tip markers

glue

scissors

Rainy Day Mural

Cut umbrella shapes out of construction paper. Hang butcher paper on a wall or a bulletin board.

On a rainy day, give each child an umbrella shape. Let the children use tempera paints and paintbrushes to create designs on their shapes. While the paint is still wet, have them put on their raincoats, go outside, and hold their shapes in the rain for a short time. Then have them bring their shapes back inside and talk about the designs created by the rain.

Attach the umbrella shapes to the butcher paper. Add construction paper handles and raindrop shapes.

Materials Needed:
butcher paper
construction paper
tempera paints
paintbrushes
scissors

Spring Garden Mural

Hang a long piece of light blue butcher paper on a wall at the children's eye level. Glue green construction paper strips across the bottom of the paper for flower stems. Use the pattern on page 77 as a guide to cut daffodil shapes out of yellow construction paper.

Set out the daffodil shapes and yellow, pink, and green cupcake liners. Let each child make a daffodil by gluing a yellow cupcake liner to a daffodil shape. Then have the children flatten the green cupcake liners and cut them in half to use for leaves. To make butterflies, have the children pinch together the middles of pink cupcake liners. Then help them twist pipe cleaners around the middles and curl the ends of the pipe cleaners to make antennae.

Let the children glue their daffodil shapes and green leaves to the stems on the butcher paper. Then attach their butterflies either to the tops of their flowers or to the blue sky background.

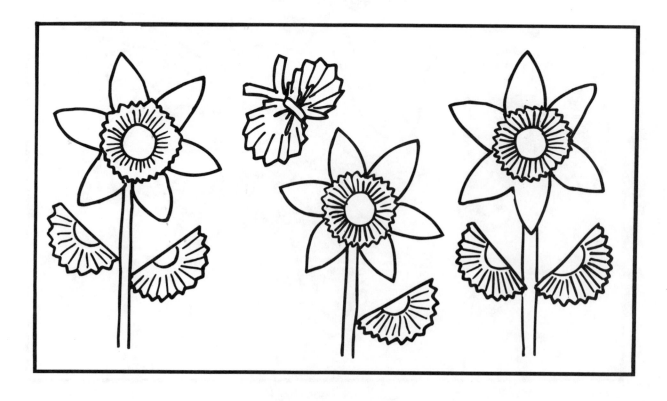

Caterpillar Mural

Pour small amounts of tempera paint into shallow containers. Cut sponges into squares. Hang a long piece of butcher paper on a wall at the children's eye level.

Give each child a paper plate and a sponge square. Let the children dip their sponges into the paint, then press them on their paper plates. Allow the paint to dry.

Hook the plates together in a row with brass paper fasteners. Add a plate with a caterpillar face drawn on it and two pipe cleaner antennae. Attach the paper plate caterpillar to the butcher paper, arranging the plates so that the caterpillar appears to be moving.

Materials Needed:

sponges
paper plates
brass paper fasteners
pipe cleaners
butcher paper
tempera paint
felt tip markers
shallow containers
scissors

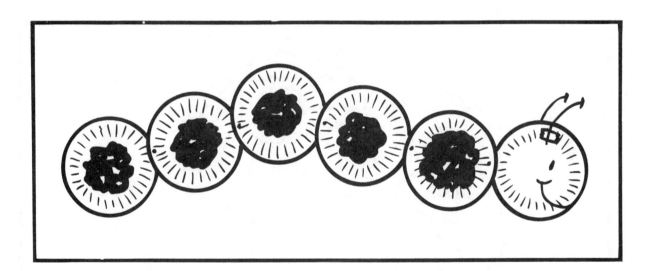

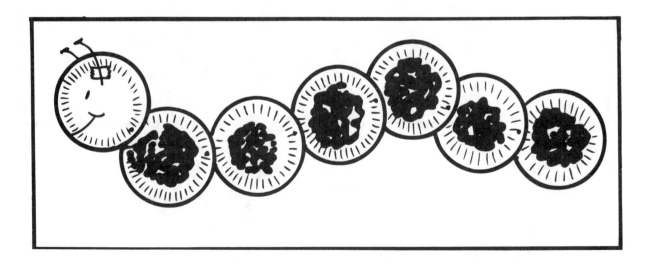

Nosegay Mural

Hang blue butcher paper on a wall or a bulletin board. Cut large paper doilies in half and attach the halves to the butcher paper in a large circle.

Give each child a small doily and several flower stickers. Let the children attach their stickers to their doilies any way they wish.

Attach the sticker-covered doilies to the butcher paper in the middle of the doily circle to complete the nosegay.

Materials Needed:

large and small paper doilies

flower stickers

blue butcher paper

scissors

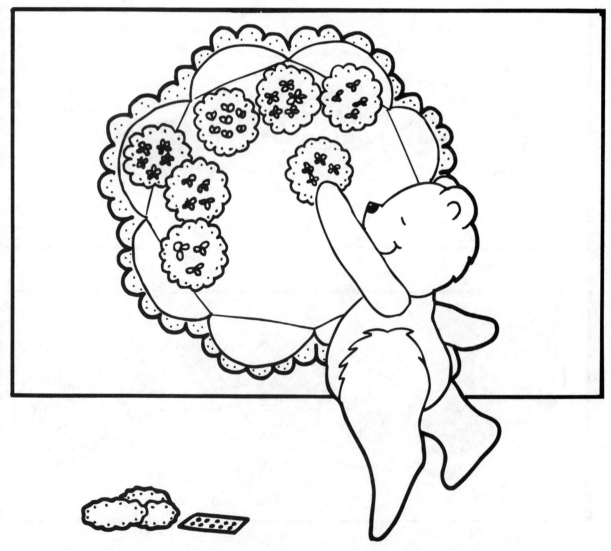

Dragon Mural

Hang butcher paper on a wall or a bulletin board. Cut a large dragon shape out of butcher paper. Cut scale shapes out of aluminum foil and green, blue, and yellow construction paper.

Give the children the foil scale shapes. Let them make textures on the foil by placing the shapes on a textured object and gently rubbing across them with their hands. Then have the children glue the foil scales and the construction paper scales all over the dragon shape.

Attach the dragon shape to the butcher paper. Use felt tip markers to add a castle and other background details, if desired.

Materials Needed:

aluminum foil

textured object

butcher paper

green, yellow, and blue construction paper

glue

scissors

felt tip markers (optional)

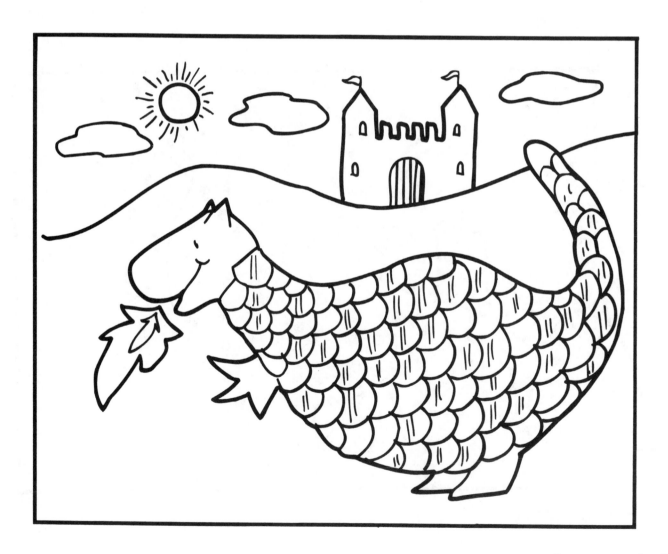

Sunflower Mural

Tape pieces of yellow construction paper together and cut a large circle out of them. Pour small amounts of glue into shallow containers. Hang butcher paper on a wall or a bulletin board. Cut yellow crepe paper into 2-by-6-inch strips.

Place the large circle on a table along with the containers of glue, the crepe-paper strips, and unshelled sunflower seeds. Have the children glue the crepe-paper strips around the edge of the circle to make petals. Then let them dip the seeds into the glue and place them all over the circle.

Attach the sunflower to the butcher paper. Add a green construction paper stem and leaf shapes.

Materials Needed:

yellow crepe paper

unshelled sunflower seeds

butcher paper

yellow and green construction paper

tape

glue

shallow containers

scissors

ruler

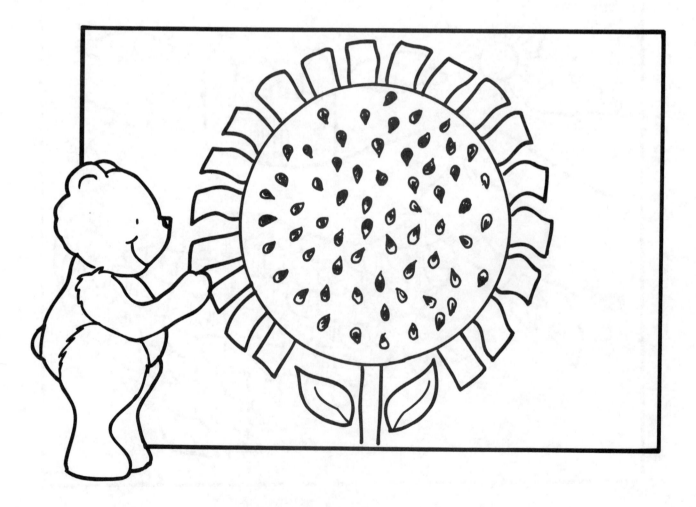

Teddy Bears' Picnic Mural

Materials Needed:

magazines
small paper plates
brown, red, and white construction paper
rinsed and dried coffee grounds
cotton swabs
glue
shallow containers
scissors

Use the pattern on page 78 as a guide to cut a bear shape for each child out of brown construction paper. Cut small pictures of foods out of magazines. Make a large checkered tablecloth out of sheets of red and white construction paper and attach it to a wall or a bulletin board. Pour small amounts of glue into shallow containers.

Give the children the bear shapes. Have them use cotton swabs to cover their shapes with a thin layer of glue and let them sprinkle rinsed and dried coffee grounds all over the glue. Set the bear shapes aside to dry. Give each child a small paper plate. Let the children glue "lunch goodies" on their paper plates using the precut pictures of foods.

Attach the bear shapes and the paper plates to the tablecloth. If desired, add a picnic basket cut out of construction paper.

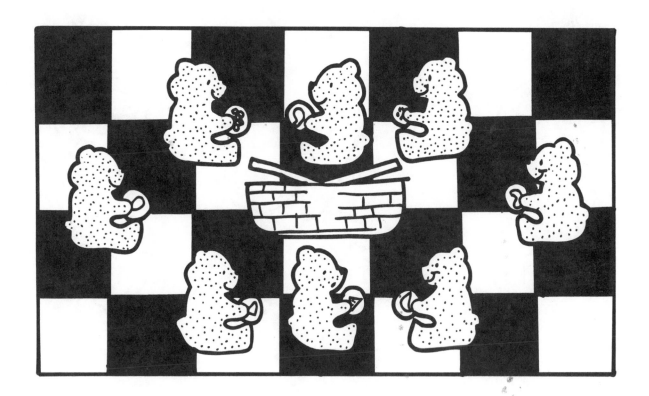

Ants at the Picnic Mural

Cut pictures of foods out of magazines. Spread a paper tablecloth on a table.

Give each child a paper plate to glue to the tablecloth. Then have the children glue the precut food pictures on the plates. Let them add "ants" to the mural by lightly touching their thumbs to stamp pads and pressing their thumbs on the tablecloth.

Hang the tablecloth on a wall or a bulletin board.

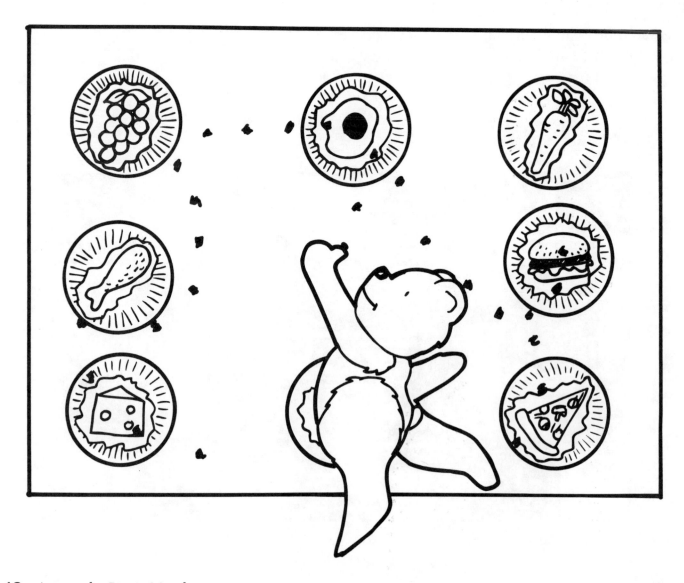

Nature Mural

Set out a fishnet and give the children small paper bags.

Go on a walk with the children. Let them use their paper bags to collect nature objects such as feathers, flowers, leaves, and grasses. When you return, let the children weave their nature objects through the holes in the fishnet. Encourage them to weave items horizontally, vertically, and diagonally.

Hang the net on a wall or a bulletin board. Continue to add nature objects as the children find them.

Materials Needed:

fishnet
small paper bags

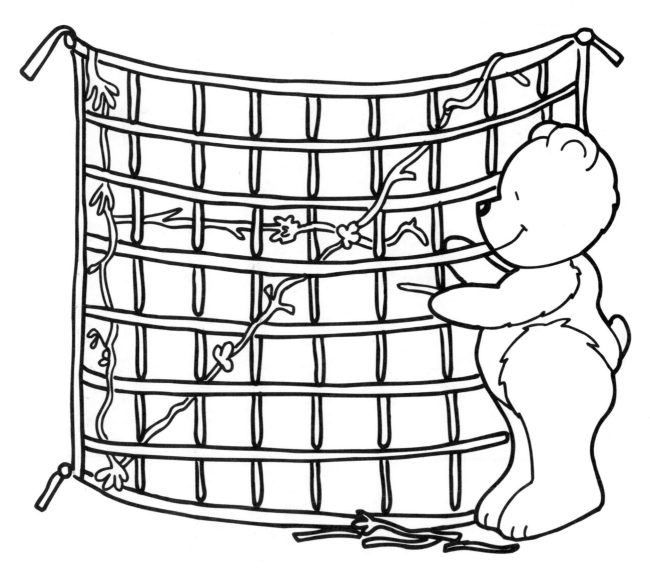

Fireworks Mural

Pour small amounts of tempera paints into shallow containers. Place black butcher paper on a table along with the paint containers and dish scrubbers.

Have the children dip the scrubbers into the paints and lightly touch them to the butcher paper to make "fireworks" prints. Let them continue until the black "sky" is filled with exploding fireworks.

Hang the mural on a wall or a bulletin board.

Materials Needed:

dish scrubbers

black butcher paper

tempera paints

shallow containers

 Variation

Let the children paint fireworks on pieces of black construction paper. Tape the papers together and hang them on a wall or a bulletin board.

Flag Mural

Hang butcher paper on a wall or a bulletin board. Cut brightly colored vinyl tape into a variety of lengths. Set out the tape strips and self-stick circles.

Give each child a piece of construction paper. Let the children attach the tape pieces and self-stick circles to their papers any way they wish to create flags.

Hang the flags in columns on the butcher paper. Add long strips of tape for flagpoles, if desired.

Materials Needed:

brightly colored vinyl tape
self-stick circles in various colors
butcher paper
construction paper
scissors

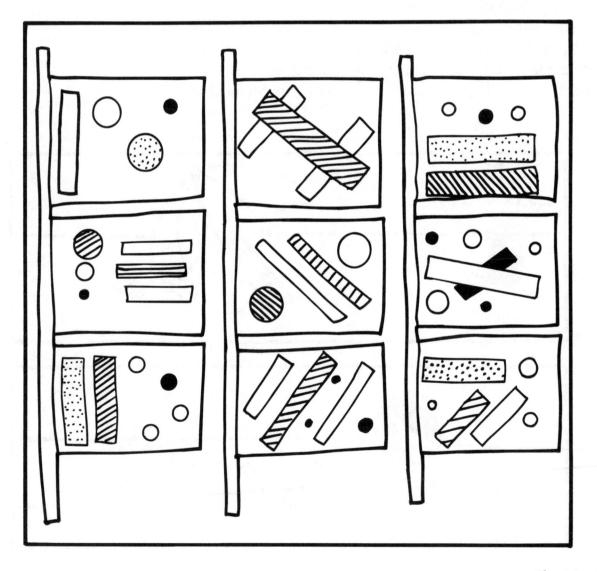

Footprints in the Sand Mural

Materials Needed:

pencil

butcher paper

light brown construction paper

blue and brown tempera paints

paintbrushes

glue

scissors

construction paper (optional)

Place a long piece of butcher paper on the floor. Use a pencil to draw a line lengthwise down the middle of the paper.

Let the children work together to paint the top half of the butcher paper blue (for the sky) and the bottom half of the paper brown (for the sand). Set the paper aside to dry. Have the children take off their shoes and stand on pieces of light brown construction paper. Use a pencil to trace around their feet and let them cut out their footprints. (If desired, have the children brush glue on their footprints and sprinkle them with sand.)

Let the children glue their footprints on the brown half of the butcher paper to make footprints in the sand. Attach the butcher paper to a wall at the children's eye level. If desired, add other shapes cut out of construction paper, such as a sun, a pail, a shovel, a beach ball, and a beach umbrella.

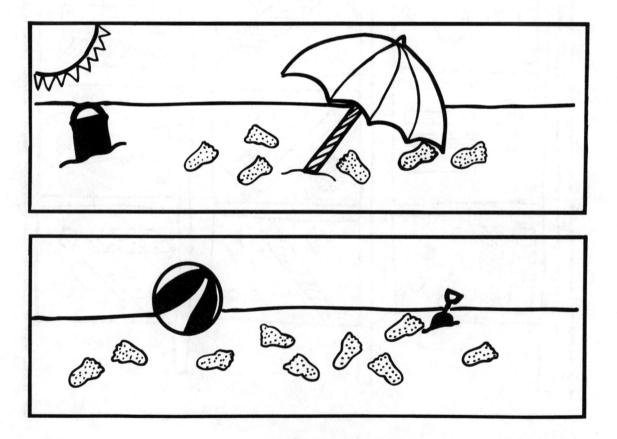

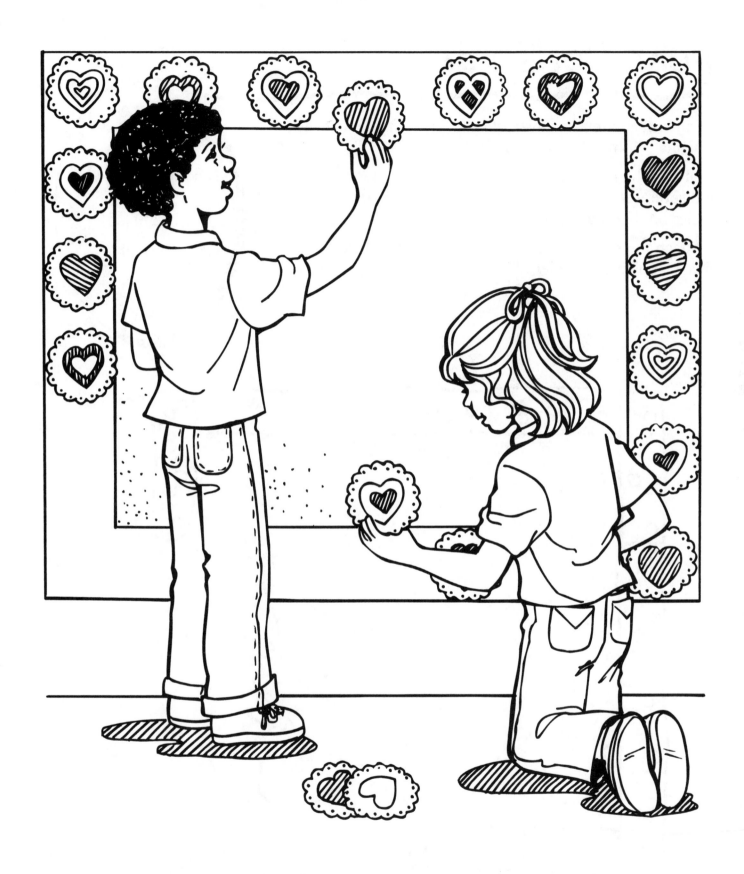

Borders

Polka Dot Border

Cut sheets of black construction paper in half lengthwise to make 4 ½-by-12-inch strips.

Give each child a strip of the black construction paper and several self-stick circles. Let the children place the circles on their papers any way they wish.

Attach the strips along the edges of a bulletin board to create a polka dot border.

Materials Needed:

self-stick circles
black construction paper
scissors
ruler

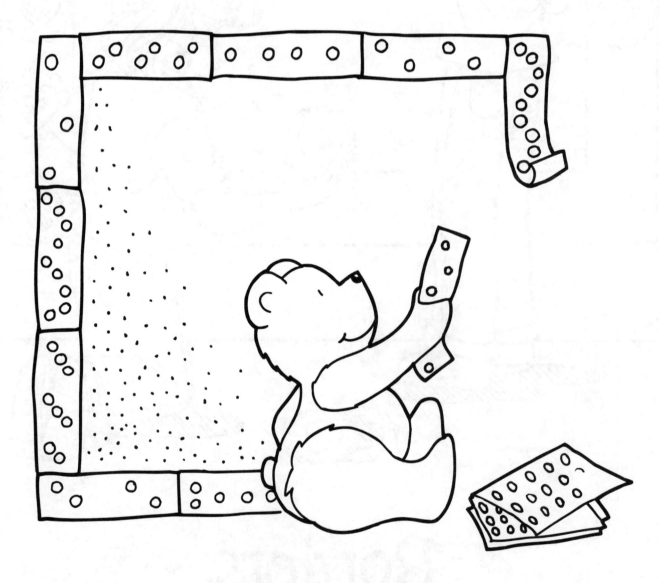

Winter Border

Cut sheets of light blue construction paper in half lengthwise as shown below to create a scalloped effect. Pour small amounts of glue into shallow containers. Set out cotton balls and the containers of glue.

Give the children the scalloped pieces of construction paper. Show them how to gently fluff out the cotton balls. Then have them dip the cotton balls into the glue and place them on their papers.

Attach the construction paper pieces, scalloped sides facing in, around the edges of a bulletin board.

Materials Needed:

cotton balls
light blue construction paper
glue
shallow containers
scissors

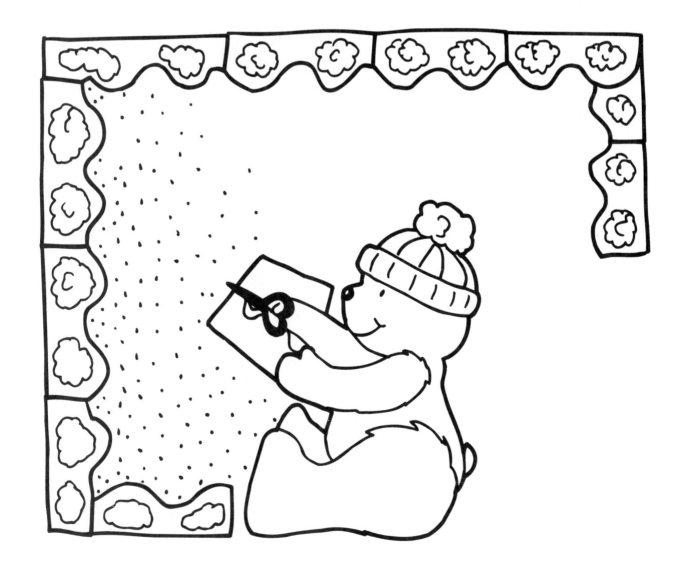

Valentine's Day Border

Cut construction paper into heart shapes small enough to fit on the paper doilies.

Give the children the heart shapes. Let them decorate their shapes with felt tip markers. Then have each child glue his or her decorated heart to the center of a doily.

Attach the doilies around the edges of a bulletin board to create a valentine border.

Materials Needed:

paper doilies

construction paper

felt tip markers

glue

scissors

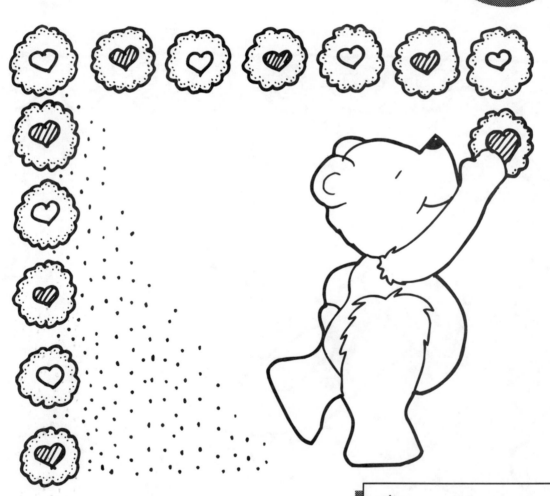

✺ Variation

Instead of heart shapes for Valentine's Day, try shamrocks for St. Patrick's Day, egg shapes for Easter, flower shapes for May Day, or tree shapes for Christmas.

Button Border

Cut sheets of construction paper in half lengthwise to make 4½-by-12-inch strips.

Give each child a strip of construction paper and an assortment of buttons. Let the children glue their buttons on their paper strips.

Attach the button-covered strips around the edges of a bulletin board.

Materials Needed:

various colors and shapes of buttons

construction paper

glue

scissors

ruler

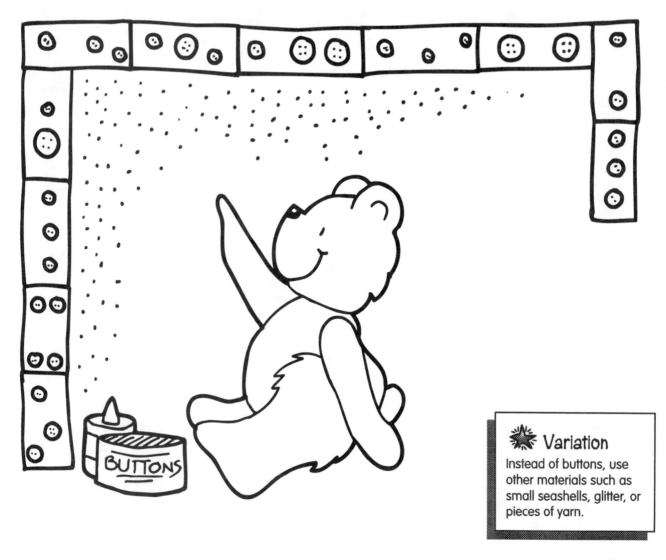

☀ **Variation**
Instead of buttons, use other materials such as small seashells, glitter, or pieces of yarn.

Tube Border

Clip a clothespin on one end of each toilet tissue tube. Pour each color of tempera paint into a separate container.

Give the children the toilet tissue tubes and paintbrushes. Have each child hold his or her tube by the clothespin and paint it one of the three colors. Allow the paint to dry.

Attach the colorful tubes along the edges of a bulletin board, making a pattern with the colors, if possible.

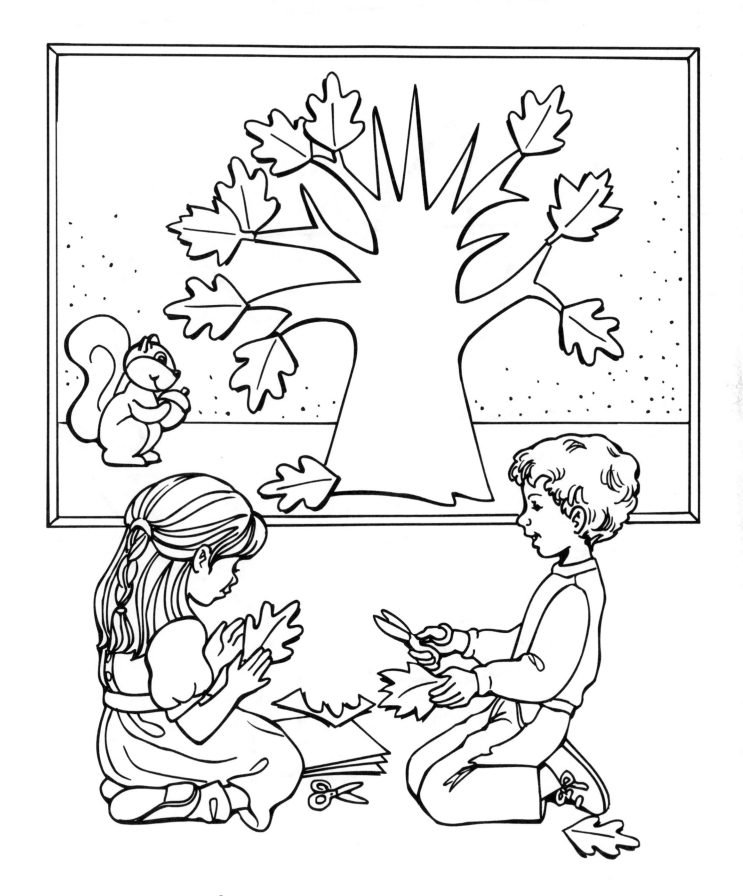

Mural Patterns

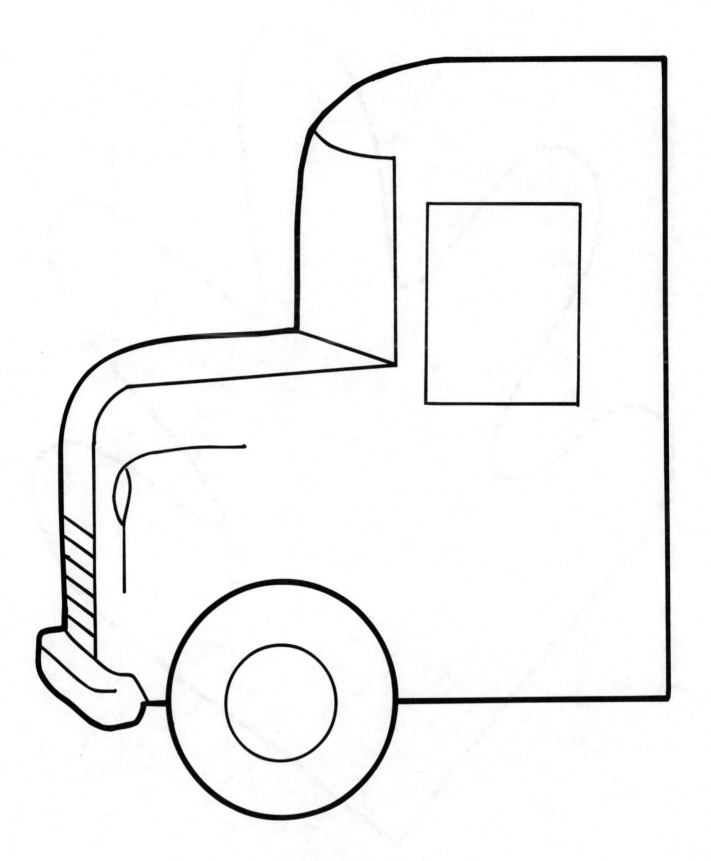

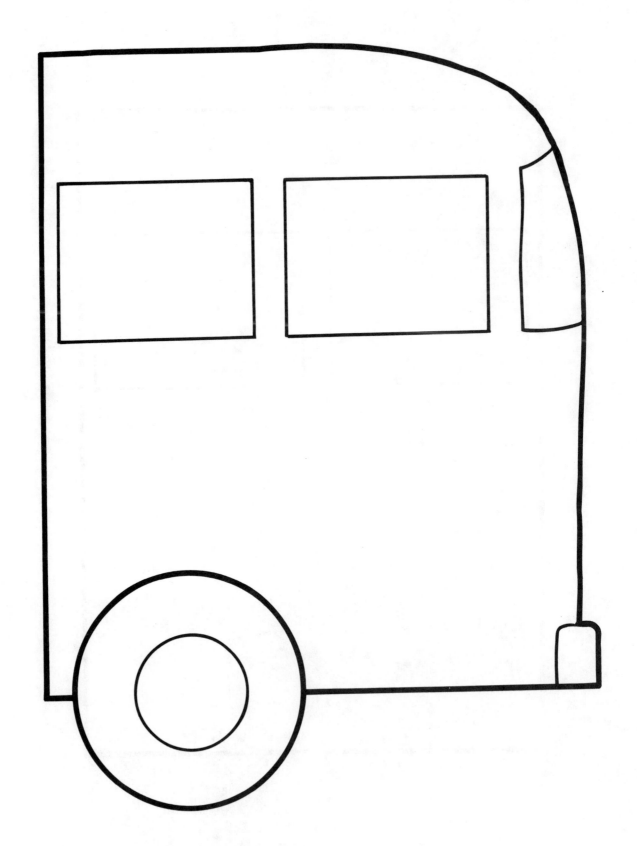

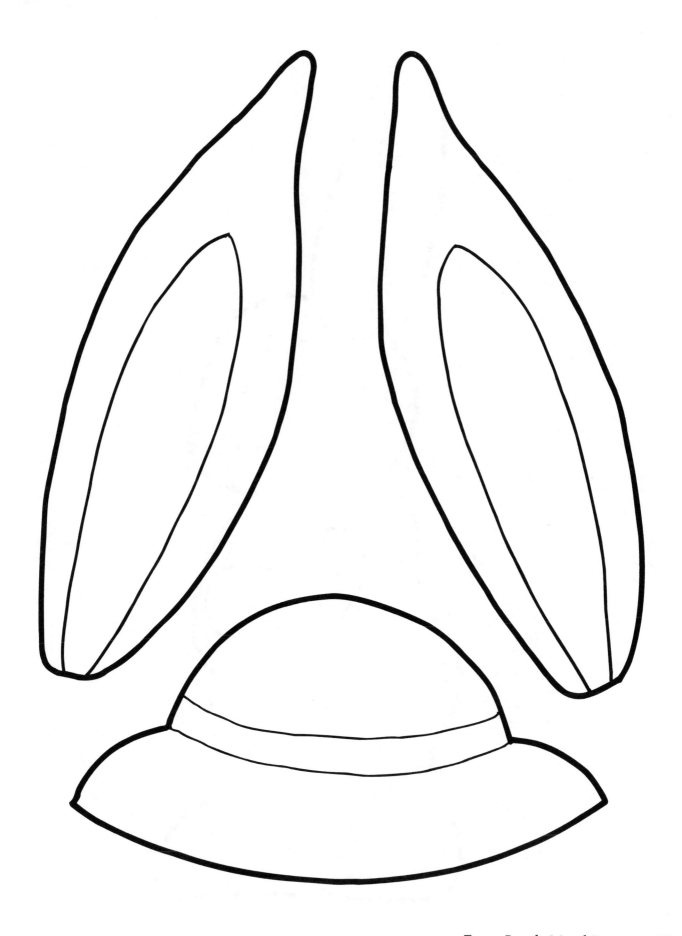

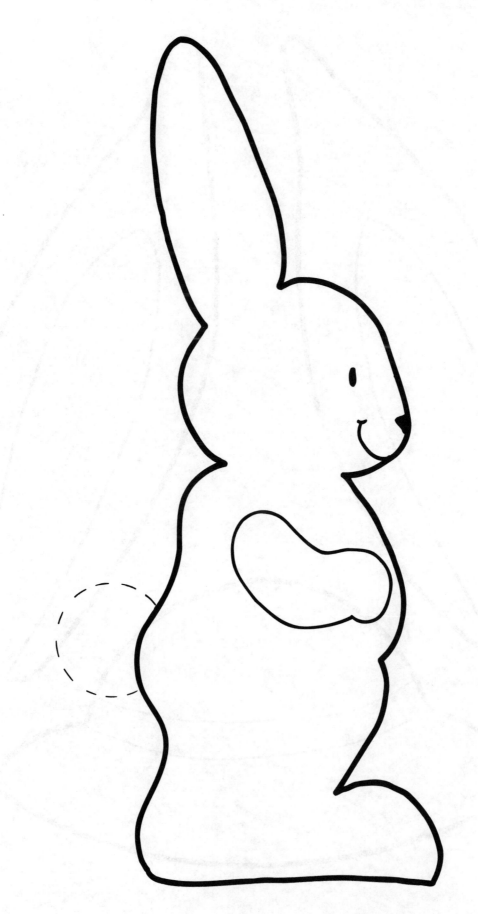

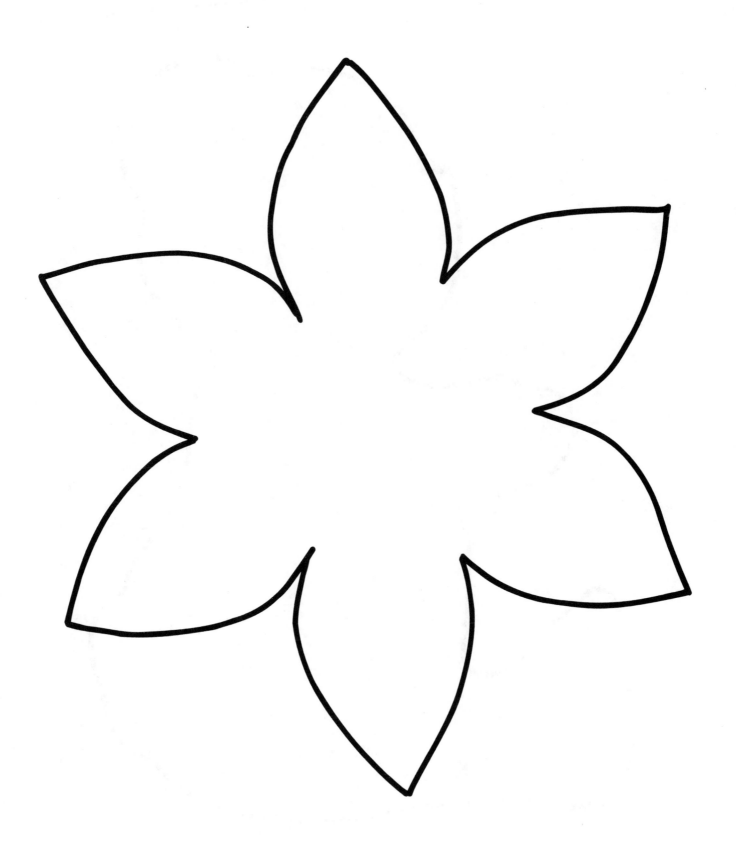

T⬧tline® PUBLICATIONS

Teacher Resources

ART SERIES
Ideas for successful art experiences.
Cooperative Art
Special Day Art
Outdoor Art

BEST OF TOTLINE® SERIES
Totline's best ideas.
Best of Totline Newsletter
Best of Totline Bear Hugs
Best of Totline Parent Flyers

BUSY BEES SERIES
Seasonal ideas for twos and threes.
Fall • Winter • Spring • Summer

CELEBRATIONS SERIES
Early learning through celebrations.
Small World Celebrations
Special Day Celebrations
Great Big Holiday Celebrations
Celebrating Likes and Differences

CIRCLE TIME SERIES
Put the spotlight on circle time!
Introducing Concepts at Circle Time
Music and Dramatics at Circle Time
Storytime Ideas for Circle Time

EMPOWERING KIDS SERIES
Positive solutions to behavior issues.
Can-Do Kids
Problem-Solving Kids

EXPLORING SERIES
Versatile, hands-on learning.
Exploring Sand • Exploring Water

FOUR SEASONS
Active learning through the year.
Art • Math • Movement • Science

JUST RIGHT PATTERNS
8-page, reproducible pattern folders.
Valentine's Day • St. Patrick's Day •
Easter • Halloween • Thanksgiving •
Hanukkah • Christmas • Kwanzaa •
Spring • Summer • Autumn •
Winter • Air Transportation • Land
Transportation • Service Vehicles
• Water Transportation • Train
• Desert Life • Farm Life • Forest
Life • Ocean Life • Wetland Life
• Zoo Life • Prehistoric Life

KINDERSTATION SERIES
Learning centers for kindergarten.
Calculation Station
Communication Station
Creation Station
Investigation Station

1•2•3 SERIES
Open-ended learning.
Art • Blocks • Games • Colors •
Puppets • Reading & Writing •
Math • Science • Shapes

1001 SERIES
Super reference books.
1001 Teaching Props
1001 Teaching Tips
1001 Rhymes & Fingerplays

PIGGYBACK® SONG BOOKS
New lyrics sung to favorite tunes!
Piggyback Songs
More Piggyback Songs
Piggyback Songs for Infants
and Toddlers
Holiday Piggyback Songs
Animal Piggyback Songs
Piggyback Songs for School
Piggyback Songs to Sign
Spanish Piggyback Songs
More Piggyback Songs for School

PROJECT BOOK SERIES
*Reproducible, cross-curricular project
books and project ideas.*
Start With Art
Start With Science

REPRODUCIBLE RHYMES
*Make-and-take-home books for
emergent readers.*
Alphabet Rhymes • Object Rhymes

SNACKS SERIES
Nutrition combines with learning.
Super Snacks • Healthy Snacks •
Teaching Snacks • Multicultural Snacks

TERRIFIC TIPS
Handy resources with valuable ideas.
Terrific Tips for Directors
Terrific Tips for Toddler Teachers
Terrific Tips for Preschool Teachers

THEME-A-SAURUS® SERIES
Classroom-tested, instant themes.
Theme-A-Saurus
Theme-A-Saurus II
Toddler Theme-A-Saurus
Alphabet Theme-A-Saurus
Nursery Rhyme Theme-A-Saurus
Storytime Theme-A-Saurus
Multisensory Theme-A-Saurus
Transportation Theme-A-Saurus
Field Trip Theme-A-Saurus

TODDLER RESOURCES
Great for working with 18 mos–3 yrs.
Playtime Props for Toddlers
Toddler Art

Parent Resources

A YEAR OF FUN SERIES
Age-specific books for parenting.
Just for Babies • Just for Ones •
Just for Twos • Just for Threes •
Just for Fours • Just for Fives

**LEARN WITH
PIGGYBACK® SONGS**
*Captivating music with
age-appropriate themes.*
Songs & Games for…
Babies • Toddlers • Threes • Fours
Sing a Song of…
Letters • Animals • Colors • Holidays
• Me • Nature • Numbers

LEARN WITH STICKERS
*Beginning workbook and first reader
with 100-plus stickers.*
Balloons • Birds • Bows • Bugs •
Butterflies • Buttons • Eggs • Flags •
Flowers • Hearts • Leaves • Mittens

MY FIRST COLORING BOOK
*White illustrations on black back-
grounds—perfect for toddlers!*
All About Colors
All About Numbers
Under the Sea
Over and Under
Party Animals
Tops and Bottoms

PLAY AND LEARN
Activities for learning through play.
Blocks • Instruments • Kitchen
Gadgets • Paper • Puppets • Puzzles

RAINY DAY FUN
*This activity book for parent-child fun
keeps minds active on rainy days!*

**RHYME & REASON
STICKER WORKBOOKS**
*Sticker fun to boost
language development and
thinking skills.*
Up in Space
All About Weather
At the Zoo
On the Farm
Things That Go
Under the Sea

SEEDS FOR SUCCESS
*Ideas to help children develop
essential life skills for future success.*
Growing Creative Kids
Growing Happy Kids
Growing Responsible Kids
Growing Thinking Kids

THEME CALENDARS
Activities for every day.
Toddler Theme Calendar
Preschool Theme Calendar
Kindergarten Theme Calendar

TIME TO LEARN
Ideas for hands-on learning.
Colors • Letters • Measuring •
Numbers • Science • Shapes •
Matching and Sorting • New Words
• Cutting and Pasting •
Drawing and Writing • Listening •
Taking Care of Myself

Posters
Celebrating Childhood Posters
Reminder Posters

Puppet Pals
Instant puppets!
Children's Favorites • The Three Bears
• Nursery Rhymes • Old MacDonald
• More Nursery Rhymes • Three
Little Pigs • Three Billy Goats Gruff •
Little Red Riding Hood

Manipulatives
CIRCLE PUZZLES
African Adventure Puzzle

**LITTLE BUILDER
STACKING CARDS**
Castle • The Three Little Pigs

Tot-Mobiles
*Each set includes four punch-out,
easy-to-assemble mobiles.*
Animals & Toys
Beginning Concepts
Four Seasons

**Start right,
start bright!**

NEW!
Early Learning Resources

For Teachers

Art Series

Great ideas for exploring art with children ages 3 to 6! Easy, inexpensive activities encourage enjoyable art experiences in a variety of ways.

Cooperative Art • Outdoor Art • Special Day Art

The Best of Totline—Bear Hugs

This new resource is a collection of some of Totline's best ideas for fostering positive behavior.

Celebrating Childhood Posters

Inspire parents, staff, and yourself with these endearing posters with poems by Jean Warren.

The Children's Song
Patterns
Pretending
Snowflake Splendor
The Heart of a Child
Live Like the Child
The Light of Childhood
A Balloon
The Gift of Rhyme

Circle Time Series

Teachers will discover quick, easy ideas to incorporate into their lessons when they gather children together for this important time of the day.

Introducing Concepts at Circle Time
Music and Dramatics at Circle Time
Storytime Ideas for Circle Time

Empowering Kids

This unique series tackles behavioral issues in typical Totline fashion—practical ideas for empowering young children with self-esteem and basic social skills.

Problem-Solving Kids
Can-Do Kids

Theme-A-Saurus

Two new theme books join this popular Totline series!

Transportation Theme-A-Saurus
Field Trip Theme-A-Saurus

For Parents

My First Coloring Book Series

These coloring books are truly appropriate for toddlers—black backgrounds with white illustrations. That means no lines to cross and no-lose coloring fun! Bonus stickers included!

All About Colors
All About Numbers
Under the Sea
Over and Under
Party Animals
Tops and Bottoms

Happy Days

Seasonal fun with rhymes and songs, snack recipes, games, and arts and crafts.

Pumpkin Days • Turkey Days • Holly Days • Snowy Days

Little Builder Stacking Cards

Each game box includes 48 unique cards with different scenes printed on each side. Children can combine the cards that bend in the middle with the flat cards to form simple buildings or tall towers!

Castle
The Three Little Pigs

Rainy Day Fun

Turn rainy-day blahs into creative, learning fun! These creative Totline ideas turn a home into a jungle, post office, grocery store, and more!

Rhyme & Reason Sticker Workbooks

These age-appropriate workbooks combine language and thinking skills for a guaranteed fun learning experience. More than 100 stickers!

Up in Space • All About Weather • At the Zoo • On the Farm • Things That Go • Under the Sea

Theme Calendars

Weekly activity ideas in a nondated calendar for exploring the seasons with young children.

Toddler Theme Calendar
Preschool Theme Calendar
Kindergarten Theme Calendar